THE LIFE AND WORKS OF

GAINSBOROUGH

Linda Doeser

A Compilation of Works from the
BRIDGEMAN ART LIBRARY

SHOOTING STAR PRESS

The Life and Works of Gainsborough

This edition printed for:
Shooting Star Press Inc.
230 Fifth Avenue – Suite 1212
New York, NY 10001

Shooting Star Press books are available at special discounts for bulk purchases for sales promotions, premiums, fund-raising, or educational use. Special edition or book excerpts can also be created to specification. For details contact: Special Sales Director, Shooting Star Press Inc., 230 Fifth Avenue, Suite 1212, New York, NY 10001

© 1995 Parragon Book Service Limited

ISBN 1-57335-031-1

Printed in Italy

Editors: Barbara Horn, Alexa Stace, Alison Stace, Tucker Slingsby Ltd
 and Jennifer Warner

Designers: Robert Mathias • Pedro Prá-Lopez, Kingfisher Design Services

Typesetting/DTP: Frances Prá-Lopez, Kingfisher Design Services

Picture Research: Kathy Lockley

The publishers would like to thank Joanna Hartley at the Bridgeman Art Library for her invaluable help.

THOMAS GAINSBOROUGH 1727-1788

THOMAS GAINSBOROUGH, THE YOUNGEST CHILD of John and Susannah Gainsborough, was born in 1727 in Sudbury, Suffolk. He was said to be a bright, clever, friendly and self-confident boy with excellent manners and a pleasant nature. Much of his character was shaped by the Suffolk countryside, where he spent many hours walking and sketching. His father was quick to recognize Thomas's ability and arranged for him to go to London to study art when he was 13 years old.

Thomas became a pupil of Hubert Gravelot, a French engraver, draughtsman and book illustrator, who introduced him to French concepts of art at a time when Italian theory dominated the British art scene, expanding the young painter's knowledge and experience. He also introduced Gainsborough to many other leading artists, including William Hogarth and Francis Hayman, whose pupil. Gainsborough later became.

Gravelot occasionally employed Gainsborough as his assistant, working on the borders of illustrations and on engravings. It was Thomas's proud boast that his years in London did not cost his father any money, for he had supported himself by selling his sketches, illustrating books and assisting established artists who required an apprentice to paint draperies and backgrounds, a common practice at the time. He was also one of the artists invited by Hogarth to contribute a painting to be hung on the walls of the new Foundling Hospital. At that time, art was very much the 'property' of rich patrons and there were no public galleries in London. Hogarth's innovative public exhibition led to the formation of the Society of Artists, which was to prove valuable to Gainsborough later.

When he was 19, Gainsborough met and fell in love with Margaret Burr, and they were married that year. Gainsborough soon recognized that he was

not yet able to compete with established London artists, so he and Margaret moved to Sudbury. In 1752 they moved to Ipswich, a larger and more cosmopolitan town than Sudbury. .Although Gainsborough's real interest was in painting landscapes, he began to undertake commissions for portraits in order to support his family, which now included two daughters. He travelled widely throughout eastern England, visiting his clients, often becoming friends with them and sometimes returning over a period of years to paint additional portraits. He also frequently painted his two daughters and his wife. During his years in Ispwich Gainsborough consolidated his technique, matured as an artist and acquired a notable reputation locally.

In 1759 the family moved to Bath. By the mid-18th century, Bath had become a centre of fashion and culture, and was an ideal city for a young artist with a growing reputation. Gainsborough hung examples of his work in the Pump Room, the generally accepted way for an incoming artist to advertise himself, and quickly received both recognition and numerous commissions. He made an excellent living in Bath and sent a constant stream of paintings to London for exhibition at the Society of Artists. He undertook a prolific amount of work, even more noteworthy because he did not follow the common practice of leaving the backgrounds and draperies of his portraits to be painted by an assistant. Unfortunately, he also did not date his paintings, which is why many of those in this book are undated.

The Royal Academy was founded towards the end of 1768, with Sir Joshua Reynolds as its first president. Gainsborough gladly accepted Reynolds' invitation to become a founder member, and his association with the Academy, while not without conflict, was extremely valuable to his career. He sent several pictures to the first exhibition in 1769, including one of his finest portraits, *Lady Molyneux*, which created a sensation. The new Academy provided a means of reaching a far wider public at exactly the time that best suited Gainsborough's artistic development.

In 1774 the family moved back to London, and took up residence in a wing of Schomberg House in Pall Mall. That same year Gainsborough was elected to the prestigious Council of the Royal Academy. However, wrangles and difficulties with the Hanging Committee dogged his dealings with the

Academy. In 1778 two of the portraits he exhibited were of well-known *demi-mondaines*, Clara Haywood and Grace Dalrymple, and their inclusion in the exhibition alongside portraits of ladies of the aristocracy was considered by some to be in poor taste. A further scandal ensued in 1782, when he submitted a portrait of Mrs 'Perdita' Robinson, mistress of the Prince of Wales.

Gainsborough was very fussy about the way his paintings were hung, and was furious when his portrait *Lady Horatia Waldegrave*, was hung low down near the fireplace, where it was almost completely concealed for much of the time by the long skirts of the women who crowded round to look at the miniatures and small paintings that were hung above the fireplace. He finally lost his temper completely the following year when the Council of the Royal Academy refused his request to hang *The Three Eldest Princesses* at a stipulated height. The painting had been designed for a specific location and had been composed with the viewer's eye level in mind. Gainsborough withdrew all his paintings from the Exhibition, provoking much public debate and many articles in the newspapers. He never exhibited at the Royal Academy again, preferring to hold private exhibitions at Schomberg House. He died in August 1788, after being stricken with cancer earlier in the year.

8

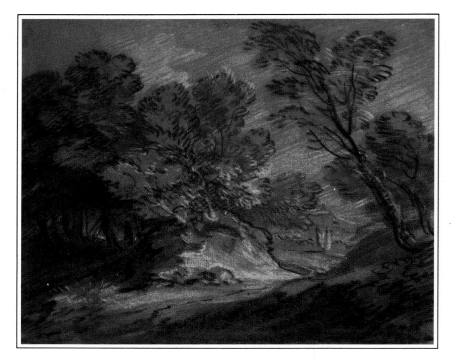

▷ **Charterhouse** 1748

Oil on canvas

WHEN WILLIAM HOGARTH, the artist, and Thomas Coram, the benefactor, decided to use the new buildings of the Foundling Hospital for an exhibition of the works of living artists, they were laying the foundations of an entirely new and public way of looking at art in England. Gainsborough was among the artists invited to contribute a painting, possibly at the suggestion of Francis Hayman. The resulting painting, while inoffensive and technically competent, gives no real indication of what was yet to come.

△ **Wooded Landscape with a Distant Mountain**

Chalk on blue paper

THROUGHOUT HIS BOYHOOD Gainsborough loved to walk through the Suffolk countryside, endlessly sketching the woods, fields and the river near Sudbury. It was after looking at some of these early drawings, with their quick, firm, sure lines and strong sense of composition and harmony, that his father prophesied, 'Tom will one day astonish the world.' Throughout his adult life, too, Gainsborough took every opportunity to travel on foot or on horseback, sketching landscapes wherever he went.

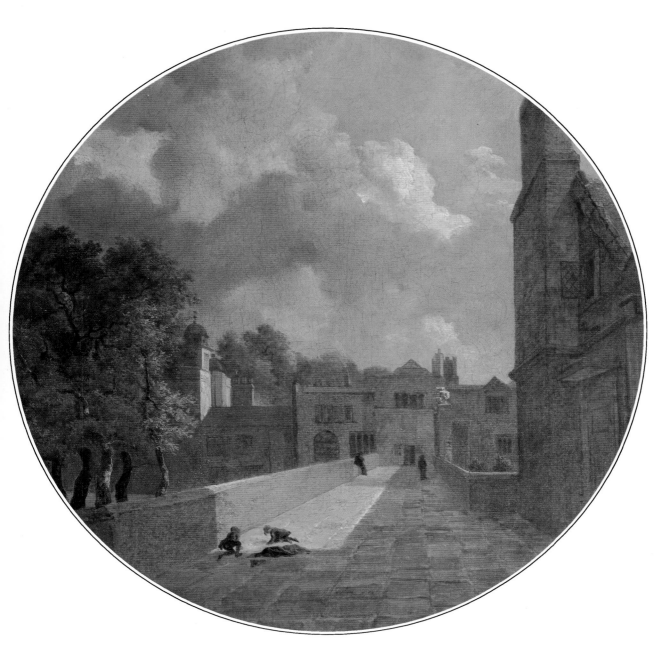

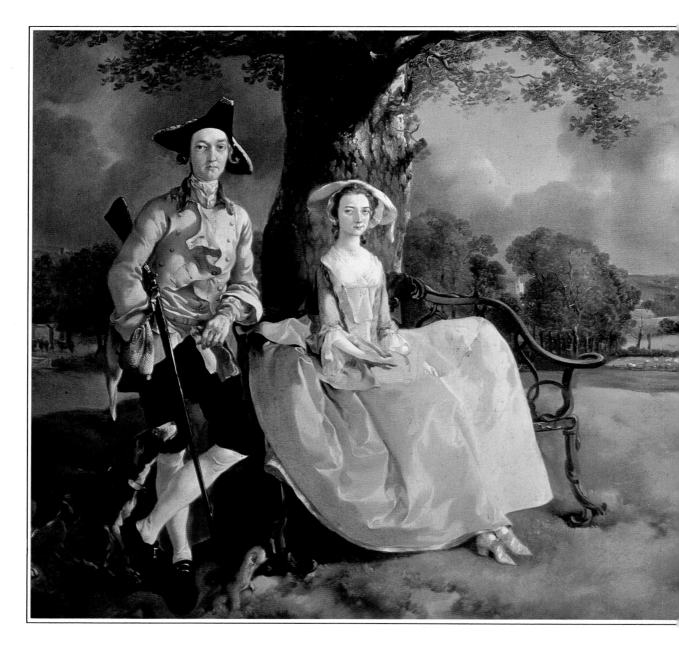

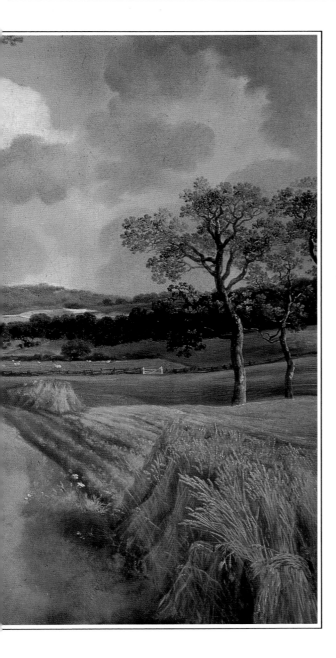

◁ **Mr and Mrs Andrews**
c. 1748-50

Oil on canvas

THIS DELIGHTFUL MARRIAGE PORTRAIT demonstrates the promise of the young painter. Placing the newlyweds so remarkably to one side and setting them in what is unmistakably a Suffolk landscape, probably a depiction of their own property, was a striking deviation from traditional practice – the figures centred in an imaginary Arcadian setting. Gainsborough often used models and dolls for the purposes of composition and there is certainly something rather stiff about Mrs Andrews' figure. Gainsborough's friend Philip Thicknesse described them as 'perfectly like but stiffly painted'. The portrait is unfinished; among other things, Mrs Andrews was to have been shown with a dead pheasant in her lap to underline her husband's prowess with a gun.

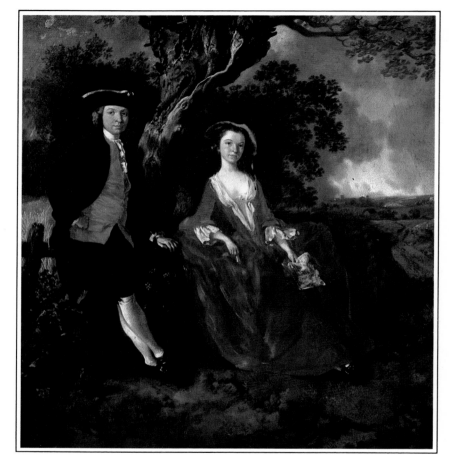

◁ **An Unknown Couple in a Landscape** 1740s

Oil on canvas

THIS IS A MUCH MORE conventional portrait than that of *Mr and Mrs Andrews* (page 11). The couple are placed more centrally in the painting and the gentleman's pose is a favourite of Gainsborough's at this period. The landscape is little more than a backdrop, although the tree directly behind the couple has been painted with a loving eye for detail. Although the lady's dress is perfunctory compared with Gainsborough's later depiction of draperies, suggesting that the work may not have been completely finished, the gentleman's waistcoat and the wrinkles in his hose betray the unmistakable hand of the master. The lady's pose is reminiscent both of Mrs Andrews' and of Mrs Gainsborough's in *The Artist with His Wife and Child* (page 15); Gainsborough was undoubtedly using dolls for models, other than when painting faces, at this time.

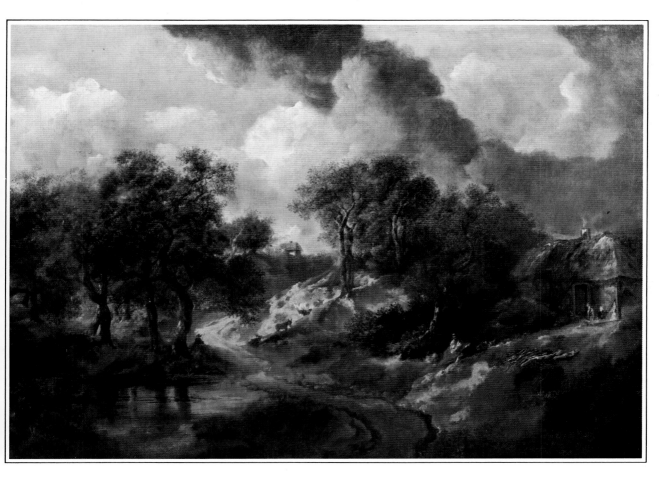

△ **Suffolk Landscape** 1748

Oil on canvas

MUCH OF GAINSBOROUGH'S early work on his return to Suffolk after his marriage was experimental, as he explored a range of techniques and styles. The influence of Dutch landscape painting is clearly seen here. The device of using light as the unifying factor, however, was one that Gainsborough would repeat and perfect throughout his career. His landscapes rarely depicted an actual topographical scene, although there is no doubt of the influence of the Suffolk countryside.

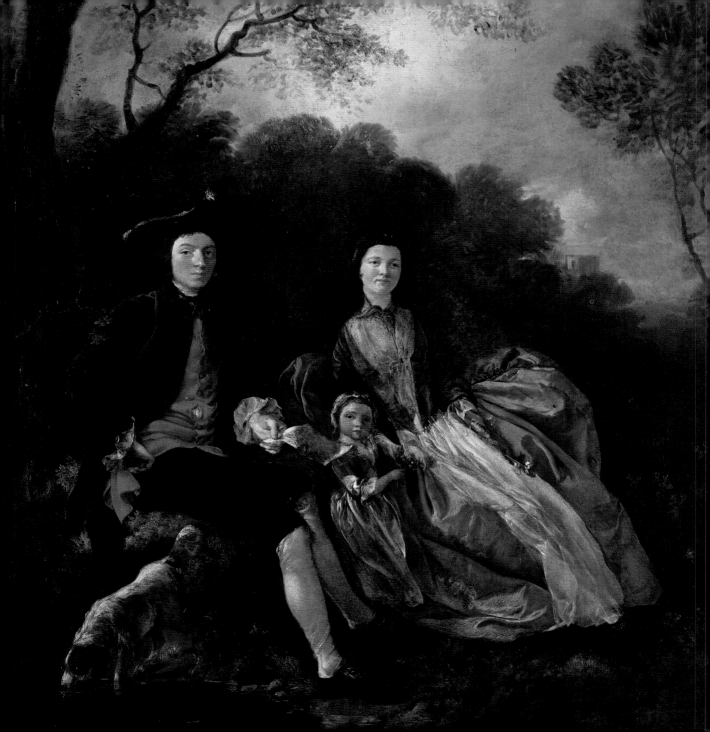

Detail

◁ **The Artist with His Wife and Child** c. 1750-1

Oil on canvas

GAINSBOROUGH WAS ONLY 19 YEARS OLD when he married Margaret Burr in 1746, so here he is still a very young, as well as quite new father. It is apparent, too, from this rather charmingly stilted portrait that he was still experimenting and acquiring technique. The figures, particularly Mrs Gainsborough and Mary, have the same rather doll-like quality seen in the earlier work *Mr and Mrs Andrews* (page 11). While the draperies – and Gainsborough was destined to become the best 'drapery man' of his time – have a certain fineness of touch, there is no real sense of flesh and blood within. The whole painting has a slightly unfinished quality; indeed, Gainsborough was well aware that he tended to work spasmodically and, in any case, if a commission came along, he could not afford to ignore it in favour of an uncommissioned portrait of his own family.

▷ **A Woodland Stream** 1750s

Chalk on grey paper

EVEN AS A BOY Gainsborough
spent many hours walking about
the Suffolk countryside sketching.
He even forged a letter from his
father to his headmaster
requesting a day off school –
demonstrating a rather different
graphic skill – so that he could
spend the time in the surrounding
woods and fields. Perhaps his
sketches and drawings, rather than
his paintings, most clearly
illustrate the remark made by John
Constable, an English landscape
painter of a younger generation,
who also knew Suffolk well: 'It is a
delightful country for a painter; I
fancy I see Gainsborough in every
hedge and hollow tree.'

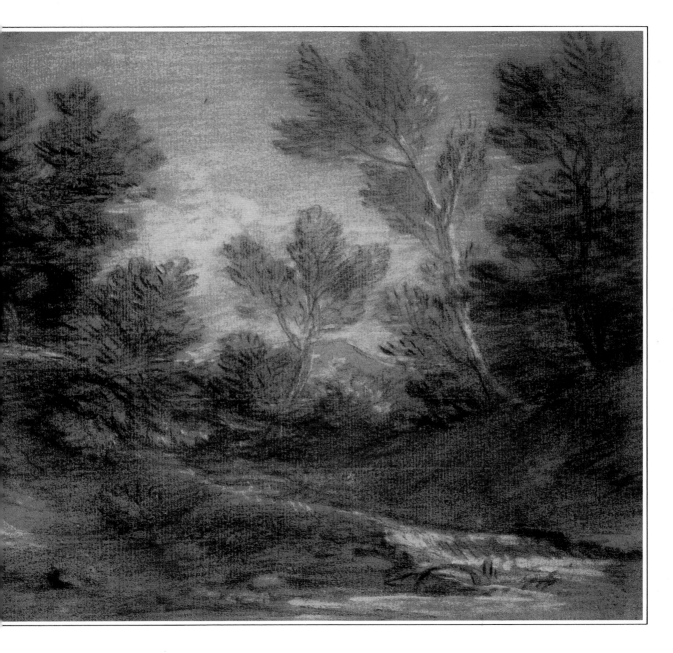

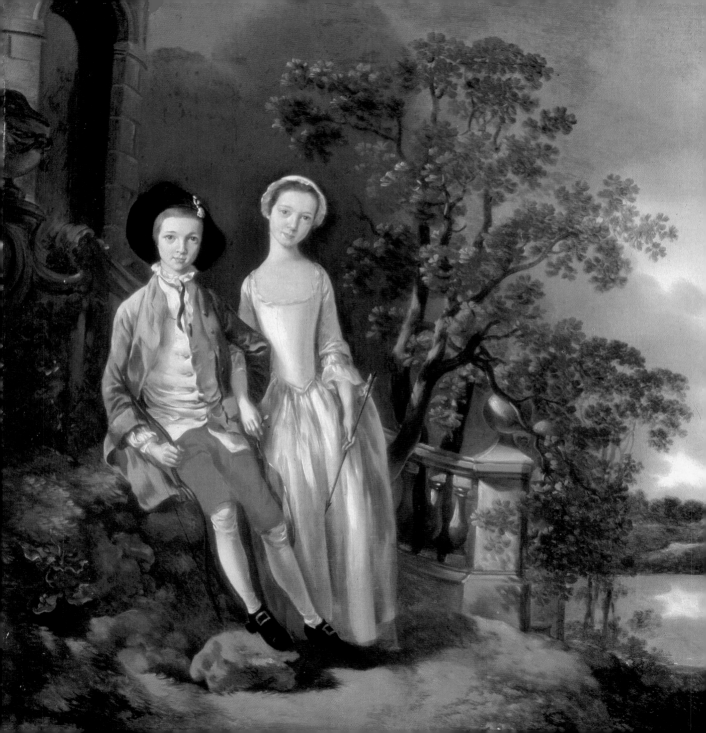

◁ **Heneage Lloyd and Sister** c. 1751

Oil on canvas

THIS CHARMING PORTRAIT sets the two children in an Arcadian landscape, something of a new genre for Gainsborough. It is an early work and may possibly not have been completed. There are several indications that Gainsborough had not yet perfected the skill with perspective and scale that he would later demonstrate with such mastery. The stone post at the end of the balustrade is slightly out of perspective, making the young girl look as if she is leaning over rather acutely. The lake is foreshortened to such an extent that the trees in the distance are out of proportion with the little tree in the foreground. It is, nevertheless, a striking work in which Gainsborough has employed the same compositional innovation of placing his sitters well to one side of the canvas as he did in *Mr and Mrs Andrews* (page 11).

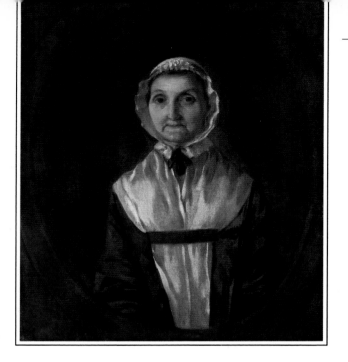

△ **Mrs John Kirby** c. 1755

Oil on canvas

GAINSBOROUGH MADE THE ACQUAINTANCE of Joshua Kirby shortly after moving to Ipswich and the two formed a close, if rather unlikely, friendship: Kirby was a man of the highest moral integrity while Gainsborough, in his own somewhat harsh judgement, was 'liberal, thoughtless and dissipated'. Kirby eventually became Clerk of the Works at Kew Palace and through his relationship with the King was able to be of great assistance in Gainsborough's career. This portrait of his mother is composed in the conventional manner that Gainsborough used during this period: full-face in a *trompe l'oeil* oval with a dark background. However, the portrait is more than a mere likeness, capturing the old lady's character, particularly in the semi-concealed smile of amusement. At this time Gainsborough found painting a series of 'standard', commissioned formal portraits irksome, but worked more freely and happily with familiar faces.

▷ **The Reverend John Chafy Playing a 'Cello**

Oil on canvas

GAINSBOROUGH WAS A PASSIONATE amateur musician, so much so, in fact, that sometimes he would spend more time with music than painting. He had many musical acquaintances, and Karl Friedrich Abel, a brilliant performer, was a close friend for nearly 30 years. He also loved beautifully made instruments and another musical friend, William Jackson, wrote: 'He had as much pleasure in looking at a violin as in hearing it. I have seen him for many minutes surveying, in silence, the perfections of an instrument, from the just proportion of the model and beauty of the workmanship.' In this painting the lively expression on the young cleric's face and the moody, romantic background are a delight, but he does seem to be holding his bow in rather an odd manner.

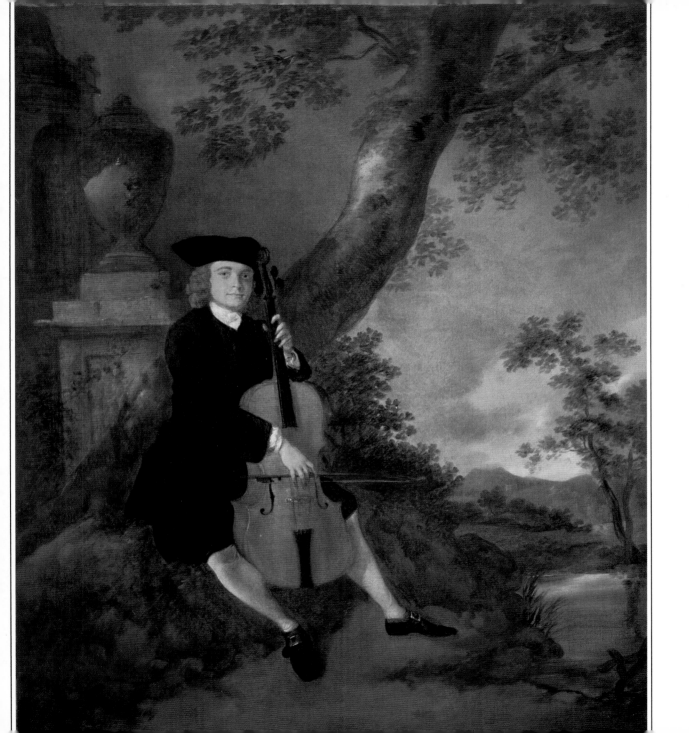

◁ **The Artist's Daughters Margaret and Mary**
c. 1758-60

Oil on canvas

GAINSBOROUGH FREQUENTLY PAINTED PORTRAITS of his family, although not all were completed. He often used the opportunity provided by working on an uncommissioned portrait to experiment with his technique and composition. This painting shows a liveliness and animation in the brushwork, although the two girls are still depicted with the smooth skin, bright eyes and exaggeratedly rosy complexions demanded of children's portraits in the 18th century.

Detail

▷ **Mr and Mrs George Byam and their Eldest Daughter, Selina** 1764

Oil on canvas

THE 'PROMENADE' WAS A FAVOURITE format for portraits and Gainsborough used it in a brilliantly inventive way in his later painting *The Morning Walk* (page 66). In this earlier work, while the pose is conventional enough, the background is wild with an almost theatrical intensity, which contrasts with the elegance of the family. Any other artist of the period would have depicted a more formal setting. At this time Gainsborough painted the landscape backgrounds of his portraits separately from the figures and was still using dolls to model the poses. There is an element of stiffness in the posture of Mr Byam and some discrepancy in the background immediately surrounding the figures.

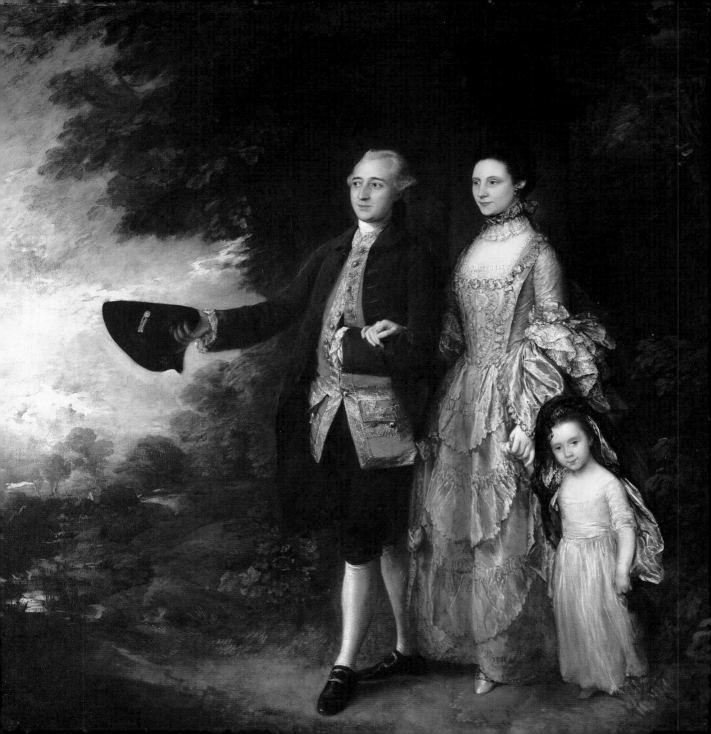

▷ **Wooded Landscape**

Oil on canvas

THIS IS A VERY TYPICAL
LANDSCAPE, both of its time and of
Gainsborough's earlier style.
People tended to think of
landscapes as being decorative
rather than fine art. In fact, they
were often described as chimney
pieces, although they might adorn
grand mansions as well as more
modest houses. Gainsborough's
technique and approach to
landscape painting evolved
throughout his life, and he can
justifiably be credited with having
invented, or reinvented, the genre
in England.

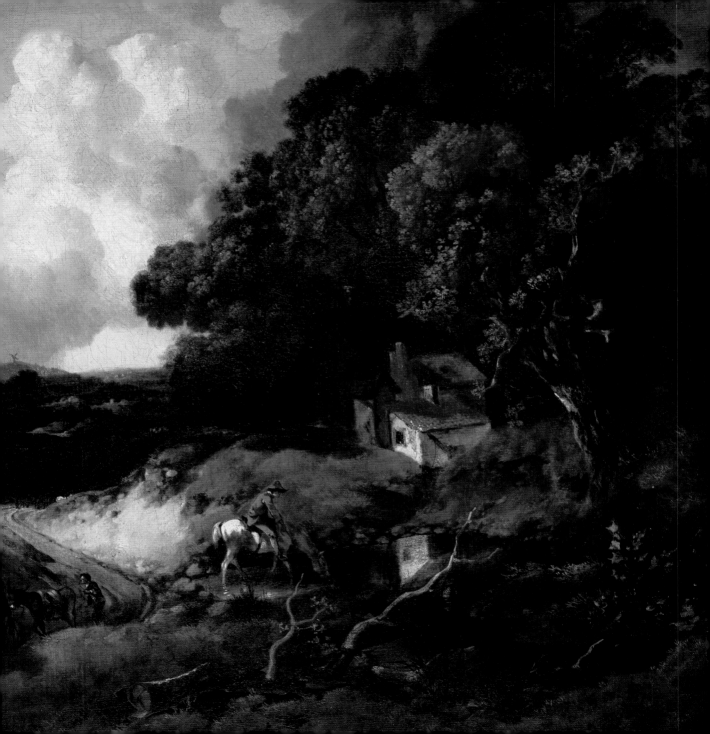

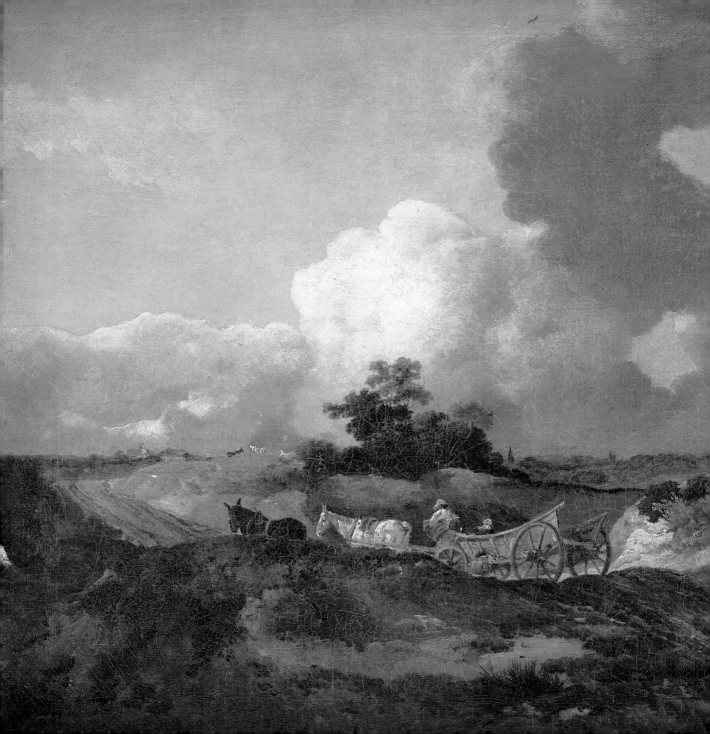

◁ **An Open Landscape in Suffolk with a Wagon on a Track**

Oil on canvas

THE POWERFUL INFLUENCE of Flemish painters, in particular Jacob van Ruysdael (c.1628-82) and, to a lesser extent Jan Wynants (c.1620-79), is apparent in all Gainsborough's early landscapes. The wool trade and other shipping that operated between the east coast of England and the Low Countries in the 18th century ensured that Gainsborough would be familiar with the art of northern Europe. Landscapes occupied a more highly respected place there than they did in England, and it was very much to Gainsborough's credit that his work inspired a new English tradition. The brooding sky and towering mass of dark cloud are typical. Equally characteristic is the device of leading the eye into the composition via the highlights.

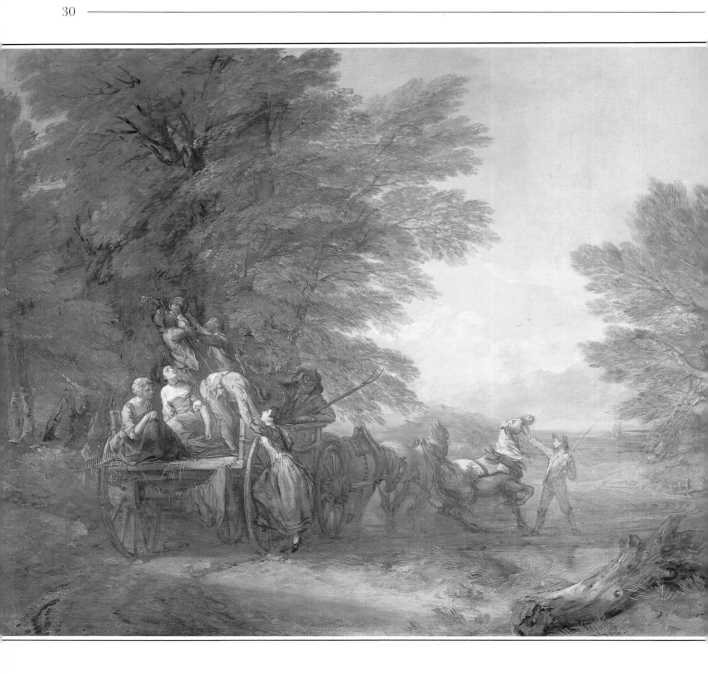

◁ **The Harvest Wagon** 1767

Oil on canvas

THIS REMARKABLE AND SUPERBLY composed painting marks not just a new confidence in his technique, but a major development in Gainsborough's approach to landscape painting. In his earlier works the landscape is central and while the figures within it are important, they are nevertheless secondary. In this instance the complex group of figures in the wagon draws the viewer's eye into the painting. The placing of the boy calming the leading horse is a masterly counterbalance. The detail, the depiction of the trees, reminiscent of his approach to draperies, and the almost tangible luminescence of the sunlight have all the hallmarks of his later more mature work. An interesting footnote is that Gainsborough's daughters were models for this painting: Margaret is the girl being helped up on to the wagon, and Mary is already aboard, looking upwards. The grey horse was painted from a real animal that belonged to Gainsborough's friend Walter Wiltshire. The artist frequently rode him when visiting the family. Gainsborough gave this painting to Wiltshire in gratitude both for his hospitality and for his unpaid services in transporting many of Gainsborough's paintings to London.

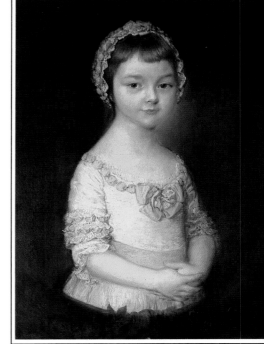

△ **Lady Georgiana Spencer** 1760s

Oil on canvas

THIS DELIGHTFUL LITTLE GIRL gazes bright-eyed straight out of the canvas and directly at the viewer, instantly capturing our attention. She appears quite relaxed, self-confident and at ease with herself, the painter and the rest of the world. (She grew up to become the Duchess of Devonshire and a patroness to Gainsborough.) This pose was a favourite of Gainsborough's and typically, too, he has not fully abandoned the *trompe l'oeil* oval of his earlier portraits, although here the shape is just subtly suggested. The pink ribbon and gathered fabric on the child's bonnet and dress are painted with the same loving attention to detail that he lavished on the draperies of his more adult female sitters.

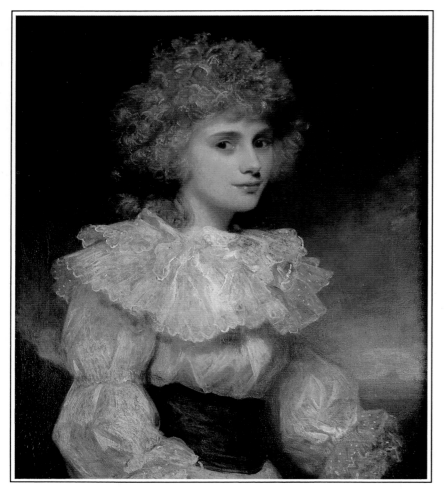

◁ **Mary, Countess of Montagu** c. 1768

Oil on canvas

BY THE LATE 1760s Gainsborough's reputation was well established and to list the portraits he produced at this time is rather like listing half the aristocracy of England. He was much admired for capturing not just the physical appearance of his subjects, but also for conveying something of their character and personality. Unlike many contemporary portrait painters, he was not inclined to flatter his sitters or make minor 'reconstructions' of their less attractive features. Perhaps because he was a sparkling conversationalist and said to be very good company – and because he liked women, particularly beautiful women – he undoubtedly had a special skill in making his sitters feel beautiful and, therefore, look at their best. This delightful portrait emphasizes the Countess's delicate features and fine complexion, while simultaneously capturing a charming quality of girlishness.

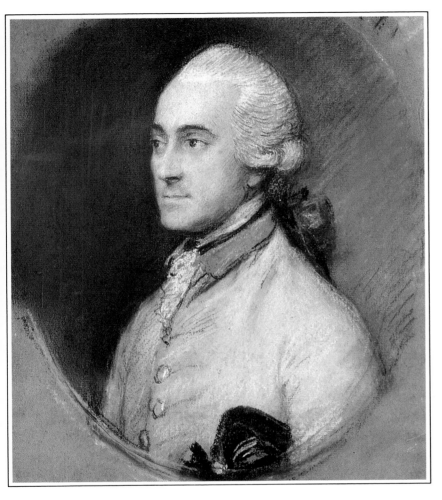

◁ **George Pitt, 1st Baron Rivers**

Watercolour

WATERCOLOUR WAS NOT A MEDIUM used much by Gainsborough, although he often sketched and made chalk drawings. This portrait shows a delicacy of touch and a confidence in the medium that is wholly typical of the artist. He understood the nature of applying colour, often using thin transparent washes and a range of experimental techniques with oils, to a far greater extent than any of his contemporaries. The subtlety and assurance of this characterful portrait conceal the skill used in its execution.

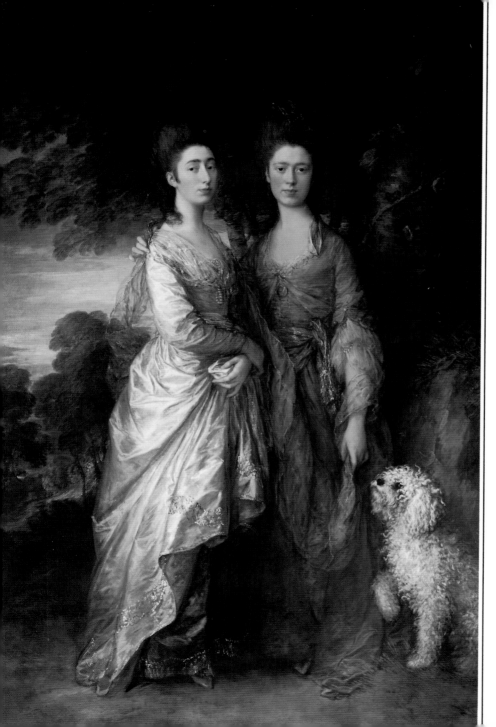

◁ **The Painter's Daughters**

Oil on canvas

DEMONSTRATING AGAIN his wonderful skill with texture and colour, Gainsborough depicts Margaret and Mary as elegant young women of fashion – in effect, the marriageable daughters of a successful man. It is interesting that Margaret never married and that Mary was married for only a matter of months after a five-year secret courtship. She married Gainsborough's friend, the musician Karl Abel Fischer, with her father's somewhat unwilling consent. Her sister, who was also in love with Fischer, did not attend the wedding. Not long after the newlyweds had settled in a furnished house provided by her father, Mary returned permanently to her parents' home.

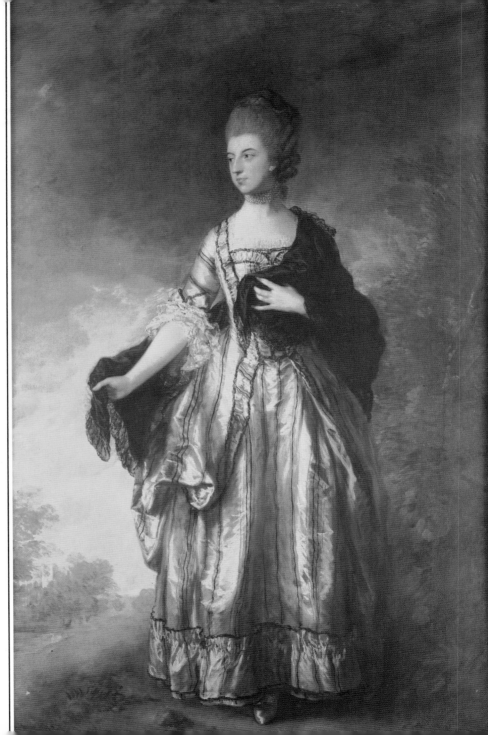

▷ **Countess Sefton** 1769

Oil on canvas

THIS FINE PORTRAIT is a perfect
example of Gainsborough's use of
light as a unifying feature. The
background reflects and deepens
the colour of the Countess's dress,
further enhancing the sense of
richly tactile, shimmering fabric.
The soft painting of the landscape,
with its expanse of atmospheric
sky, serves to emphasize the figure
in the foreground. It is a painting
of great grace and harmony. the
only contemporary English
portraitist who might be
considered a rival to
Gainsborough was Sir Joshua
Reynolds. Gainsborough's skill at
encapsulating character and his
individual technique in applying
layers of paint to create the texture
of silks, lace and other fabrics
surpassed even the mastery of
Reynolds.

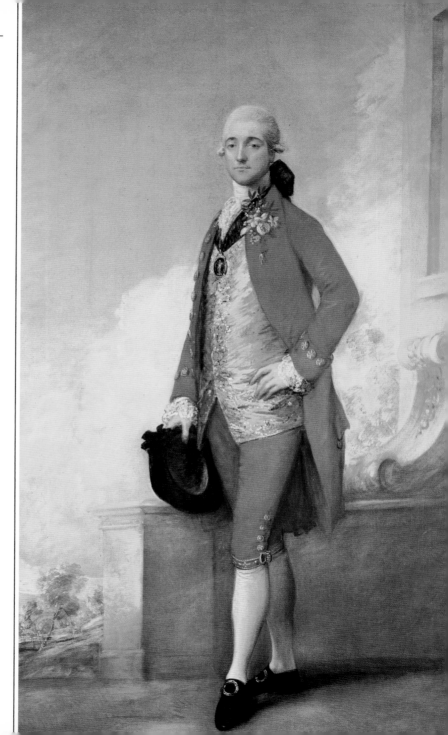

▷ **Captain Wade, Master of Ceremonies at Bath** 1771

Oil on canvas

ONCE HE HAD BECOME well established in Bath, Gainsborough was kept very busy and, following the founding of the Royal Academy in 1768, he was fully occupied with what he described as 'daubing away for the Exhibition'. (He was also 'daubing' at the rate of 100 guineas for each full-length portrait.) Captain Wade is seen here in his most elegant regalia, complete with an elegant spray of flowers. The background is very restrained, emphasizing the richness of the clothes and a subtle portrayal of self-satisfaction in the unmoving features and very slightly effete pose.

▷ **Miss Theodosia Magill,
Countess Clanwiliam**

Oil on canvas

THIS (AND A SLIGHTLY darker)
shade of blue was one of
Gainsborough's favourites, and is
a colour he employed to excellent
effect on many occasions. In this
skilful and charming portrait he
again, demonstrates his
exceptional ability to convey the
feel and texture of the rich folds of
the dress and the delicate frill of
lace. Sometimes Gainsborough
would paint lace in a way that just
hinted at its wispy presence, while
at others, as here, he gives it its full
decorative value, depicting the
design with the same elaborate
care as the original lacemaker.

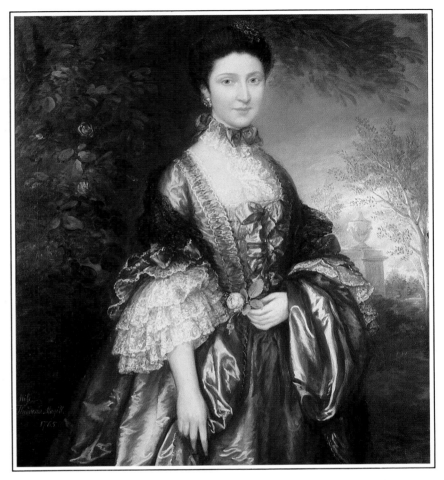

▷ **Landscape with House**

Oil on canvas

THIS DELIGHTFUL LANDSCAPE is
quintessentially English, yet the
influence of both Dutch and
French painters, as well
Gainsborough's own unique eye, is
apparent. The entire composition
– the topography, the leaning
trees, the arrangement of the
figures and the light – is framed to
lead the eye to the house in the
distance. So finely painted are the
details, however, that the eye then
ranges across the scene, finding
more and more to examine.

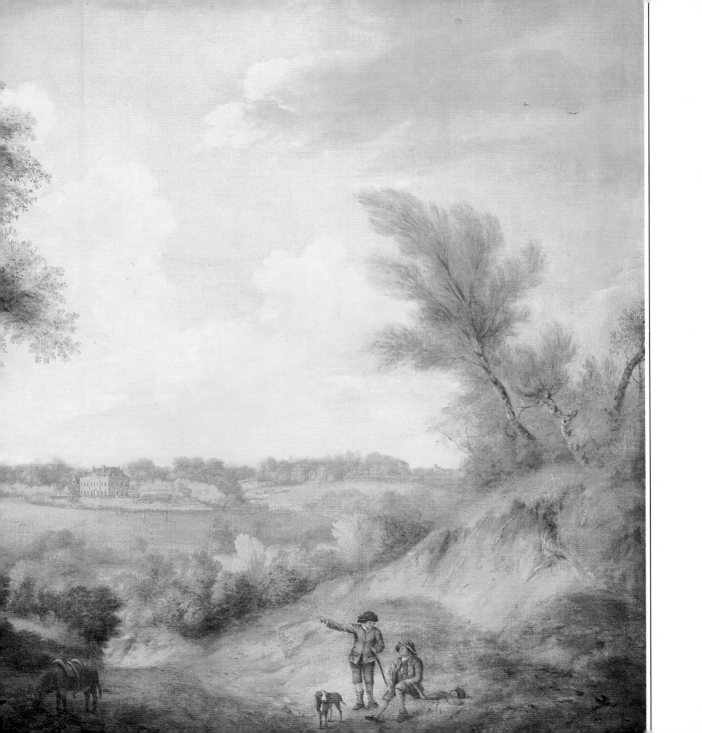

◁ **David Garrick** c. 1771

Oil on canvas

THE ACTOR DAVID GARRICK was
a lifelong friend. The original
acquaintance was made in
Gainsborough's early days in
London through Hubert Gravelot
and flourished during the years in
Bath, where Garrick frequently
appeared. Gainsborough painted
his friend's portrait more than
once. Of the first painting,
destroyed by fire in 1946, he said
that he 'never found any portrait
so difficult to hit as that of Mr
Garrick'. He painted the actor
again especially for Mrs Garrick,
but delayed sending the work to
her because he wanted to make a
copy to hang in his own parlour.
He eventually sent the original
with a charming letter that
concluded with the wish, 'That
you may long continue to delight
and surprise the world with your
original face whilst I hobble after
with my copy...'.

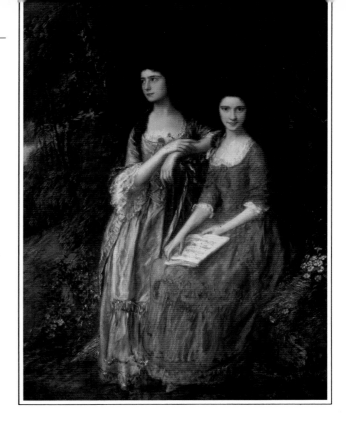

▷ **The Linley Sisters (Mrs Sheridan and Mrs Tickell)** c. 1772

Oil on canvas

GAINSBOROUGH PAINTED a series of portraits of the Linley sisters (together and separately), and his affection for them and towards their father, Thomas Linley, is very apparent in this fine work. Mary's direct gaze at the onlooker immediately engages the attention, and the entire composition is a harmonious unification of the two women and their surroundings. The brushwork is delicate and incorporates a wide range of techniques. In some places the paint is extremely thin and the highlights have been scratched off rather than flicked on. In his 14th Discourse to students of the Royal Academy, Sir Joshua Reynolds spoke of Gainsborough's use of this technique. 'It is certain that all those odd scratches and marks, which, on a close examination, are so observable in Gainsborough's pictures, and which even to experienced painters appear rather the effect of accident than design; this chaos, this uncouth and shapeless appearance, by a kind of magick, at a certain distance assumes form, and all the parts seem to drop into their proper places.'

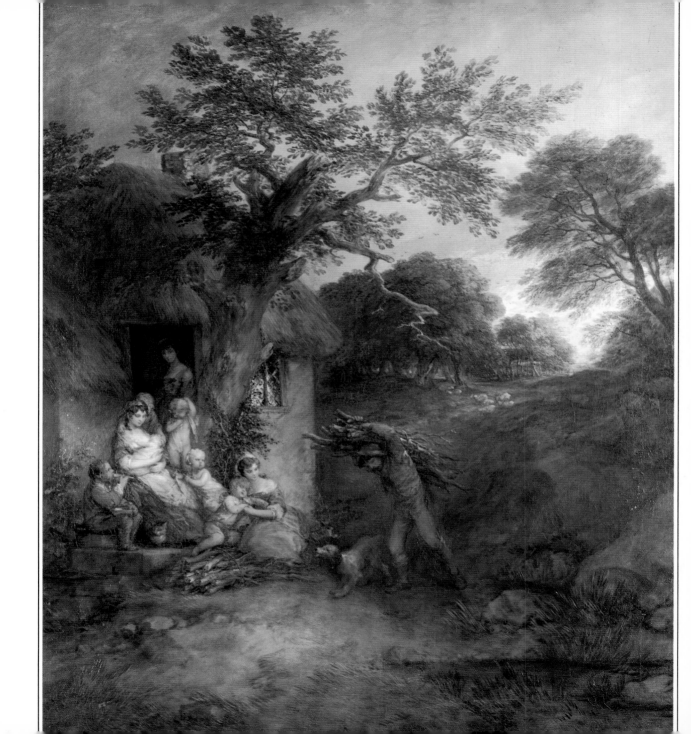

◁ The Woodcutter's House
c. 1772-3

Oil on canvas

ALSO KNOWN AS *The Woodcutter's Return*, this is one of several paintings depicting a tranquil rural idyll. The family is well fed and comfortably housed as father returns from his day of honest toil. Even the dog looks plump and well cared for. It is not a surprise that it was bought by the land-owning Duke of Rutland in 1778. In spite of the Englishness of the subject, however, the group at the cottage door forms a complex arrangement of figures with a distinctly artificial and Italian feel to them.

▷ The Hon. Mrs Graham
c. 1775-7

Oil on canvas

THIS IS A CLASSICAL EXAMPLE of a society portrait – what Gainsborough himself termed a pot-boiler. The brilliant depiction of the luxurious fabrics, feathers and other trimmings is a bravura display of his extraordinary talent. He used a technique of applying layers of translucent paint, producing an exceptional depth of colour. The classical setting with its elongated columns is intended to indicate the lady's nobility and culture, and the composition is much more conventional and restrained than Gainsborough's rather more exuberant portraits of friends.

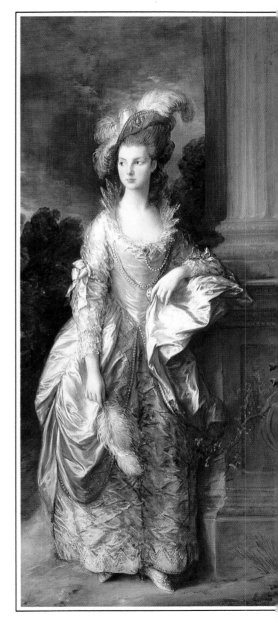

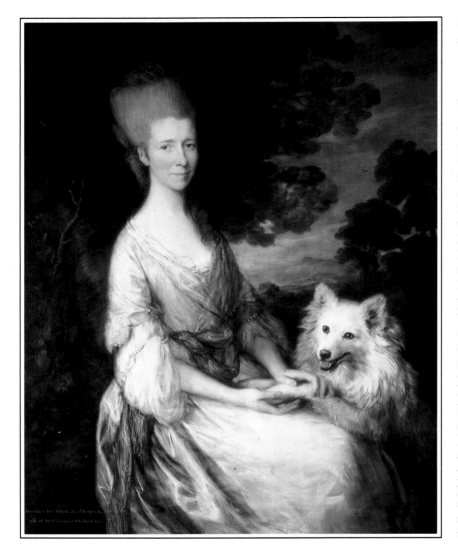

▷ **Sir Christopher Whichcote
and**
◁ **Jane, Lady Whichcote**
1775

Oil on canvas

THESE COMPANION PORTRAITS are
typical examples of what
Gainsborough tended to refer to
as 'phiz-mongery', yet both are
executed with great skill and there
is no reason to doubt that they
were anything other than excellent
likenesses. In both instances the
landscape is used as an effective
method of framing the figure. The
Earl, like many of Gainsborough's
portraits of men, is painted in a
very down-to-earth, no-nonsense
style. He is a solid figure, literally
and metaphorically, and there is
nothing extravagant about his
portrayal. Lady Whichcote, on the
other hand, while by no means a
beautiful woman, is presented with
a degree of softness and femininity.
Her dog, obviously a favourite
companion, also serves the
purpose within the composition of
picking up the colours of the
sitter's clothes and the background
sky and acting as a harmonious
intermediary.

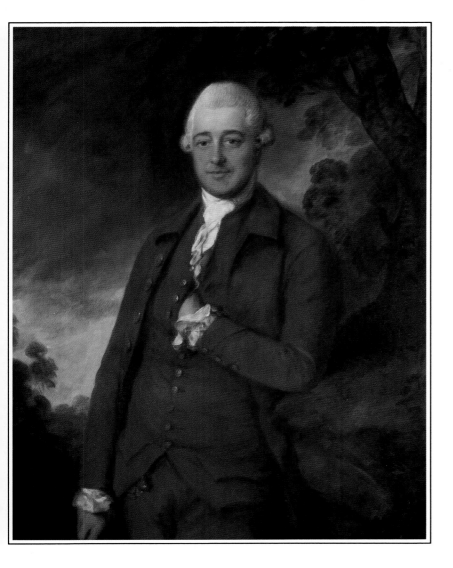

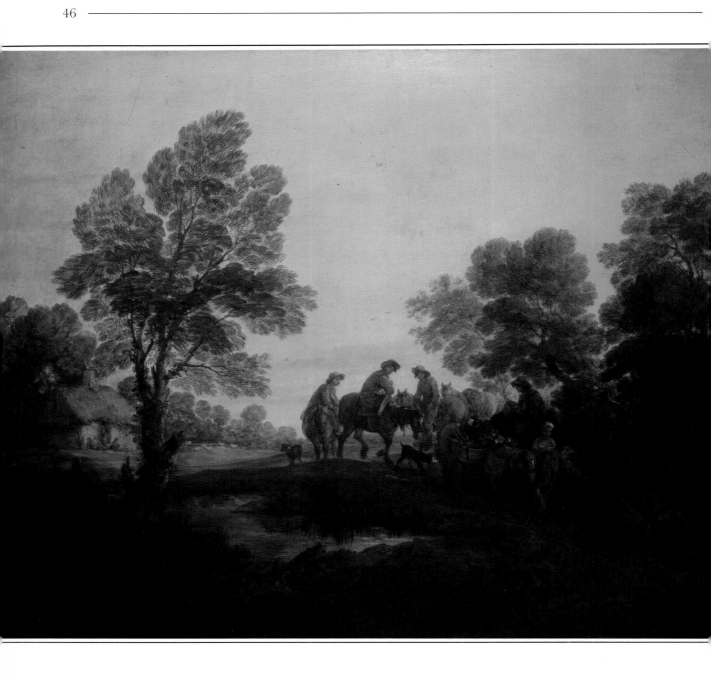

◁ Going to Market Early

Oil on canvas

SIR JOSHUA REYNOLDS DEVOTED his 14th Discourse to students of the Royal Academy to Gainsborough. Speaking of Gainsborough's meticulous approach to landscape painting, he said, 'From the fields he brought into his painting room stumps of trees, weeds, and animals of various kinds and designed them not from memory, but immediately from the object. He even framed a kind of model from landscapes on his table; composed of broken stones, dried herbs and pieces of looking-glass, which he magnified and improved into rocks, trees and water.' This painting is more than a straightforward landscape, as the eye focuses on the fairly complex group of animals and peasants almost silhouetted against the early morning light.

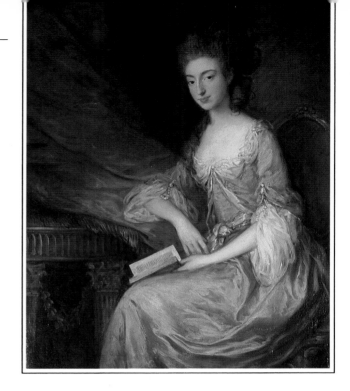

△ Lady with a Book

Oil on canvas

GAINSBOROUGH WENT TO extraordinary lengths with his technique to ensure that what the viewer saw at eye level would be what he, the painter, intended. During the last years of Gainsborough's life John Smith, then a mere boy but later the Keeper of the Prints and Drawings at the British Museum, used to visit him in company with the sculptor Joseph Nollekens (1737-1823). He often watched Gainsborough paint and observed,

'I was much surprised to see him sometimes paint portraits with pencils on sticks full six feet in length, and his method of using them was this: he placed himself and his canvas at a right angle with the sitter, so that he stood still and touched the features of his picture exactly at the same distance at which he viewed his sitter.'

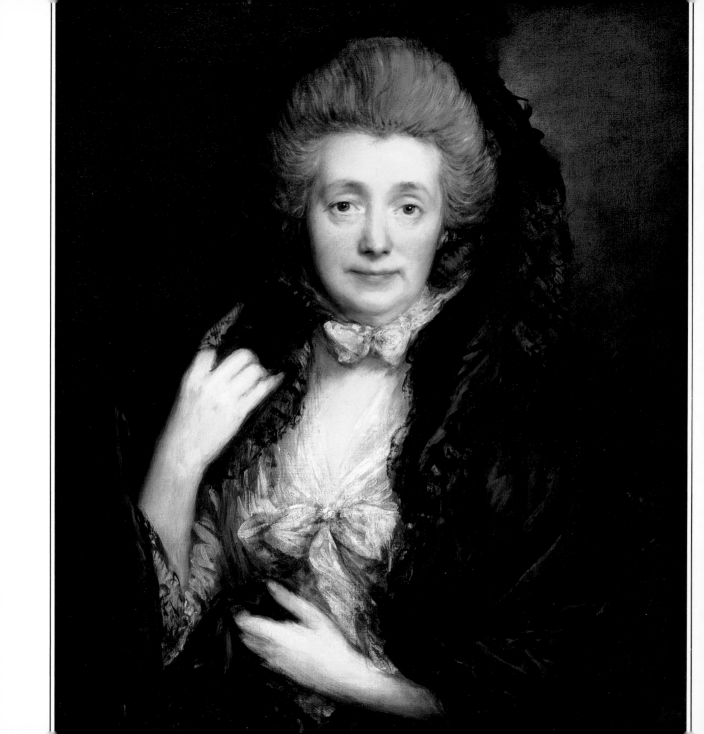

◁ **Mrs Gainsborough**
c. 1778-9

Oil on canvas

THERE ARE NOT MANY DETAILS
known about Margaret
Gainsborough's life. It is known
that there were times of marital
discord, and biographers, naturally
interested in the artist himself, have
tended to be partisan. This portrait,
one of many, is, perhaps, the answer
to their criticisms of her. Painted
with genuine love and
understanding, it is full of vivacity
and movement. It harks back in
composition to the formalized
portraits of Gainsborough's early
years, but the *trompe l'oeil* oval has
been replaced by black lace, and the
sitter, far from being content to
remain simply a subject, is full of
lively intelligence. Gainsborough
was aware that he fell far short of the
perfect husband; a philanderer, a
prodigal, although generous, man,
sociable to the point of selfishness
with his time and very sharp
tempered. Some 10 years later,
when he knew he was dying, it was
Margaret Gainsborough to whom
he turned for strength and support,
finding peace in the knowledge that
her much criticized frugality had
provided for her widowhood and
the future of their daughters, and
giving her detailed instructions
about his funeral and grave.

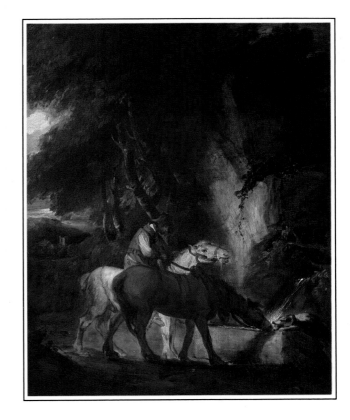

△ **Horses Drinking at a Trough** 1780

Oil on canvas

IN THE 1780s GAINSBOROUGH
began painting what he called his
'fancy pictures'. In these he
depicted country folk, often
children, in a romanticized rural
setting. In effect, he created a kind
of English Arcadia and it became
one of his favourite forms. This
painting is more fully known as
*Rocky Wooded Landscape with a
Mounted Drover, Horses Watering at a
Trough* and *Distant Village and
Mountains*, which fully sums up the
romantic image of an idealized
rural community.

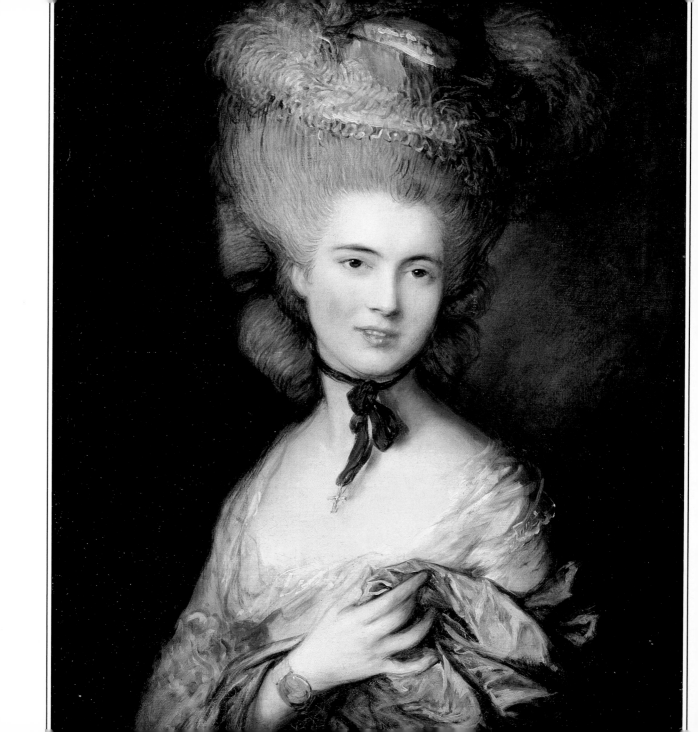

Detail

◁ **Portrait of the Duchess of Beaufort**

Oil on canvas

THE GRACE AND DELICACY of Gainsborough's portraiture is reminiscent of that of Van Dyck, the great Dutch painter at the court of King Charles I a century earlier. This is by no means incidental; not only was Gainsborough familiar with Van Dyck's work, he was an enormous admirer, and such comparisons between them would have rejoiced his heart. Producing a 'likeness' was, after all, what he was paid for, but encapsulating personality, breathing life into the portrait and capturing the incidental detail with such breathtaking accuracy and definition are what made Gainsborough such a master and enabled him to outshine all his contemporaries, including even Sir Joshua Reynolds.

Detail

▷ **Portrait of Sir Edward Willes in Judge's Robes**

Oil on canvas

GAINSBOROUGH DID NOT particularly enjoy painting men, but loved to paint women. However, he clearly enjoyed himself with this portrait, perfectly capturing the judge's knowing look and wry sense of humour. Gainsborough was very much a man of the world and recognized a similar wealth of experience and good-natured tolerance of other people's weaknesses in his subject. There is, however, a firmness and strength in the judge's features that suggest that neither he nor Gainsborough would confuse tolerance with licence.

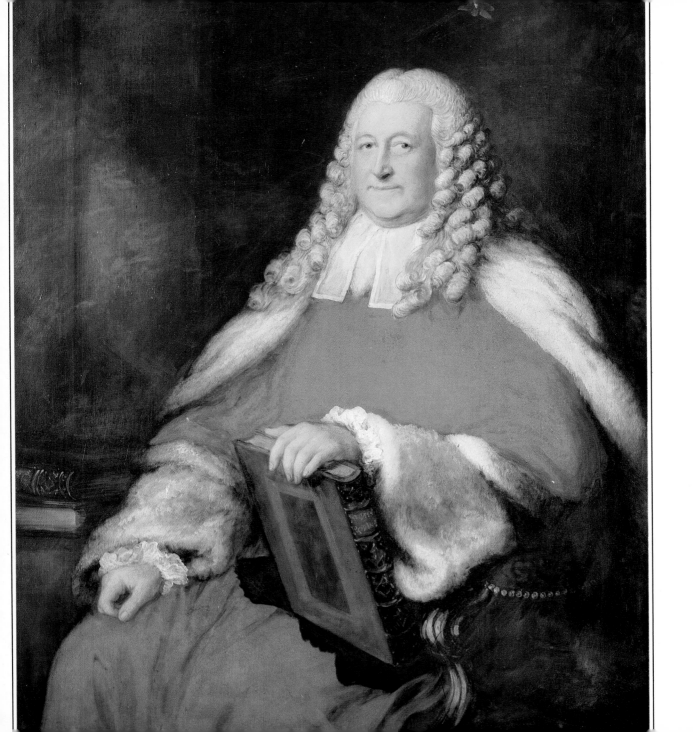

▷ **Pomeranian Bitch and Puppy**

Oil on canvas

IT WAS QUITE COMMON in the
18th century for the aristocracy to
commission portraits of their
animals, especially their horses
and dogs. Indeed, some artists
made a substantial and successful
living out of painting only
animals. Gainsborough certainly
loved to use them as subjects;
many family pets are included in
his portraits and they feature in a
number of 'fancy pieces'. The
long, silky coat of the mother dog
and the soft, fluffy coat of the
puppy in this delightful study have
been depicted with the same
loving care and tactile quality that
Gainsborough applied to drapery.
Any dog lover will immediately
recognize the intelligence in the
bitch's eyes and the lively way her
ears are pricked. Equally typical
is the curiosity demonstrated by
the puppy.

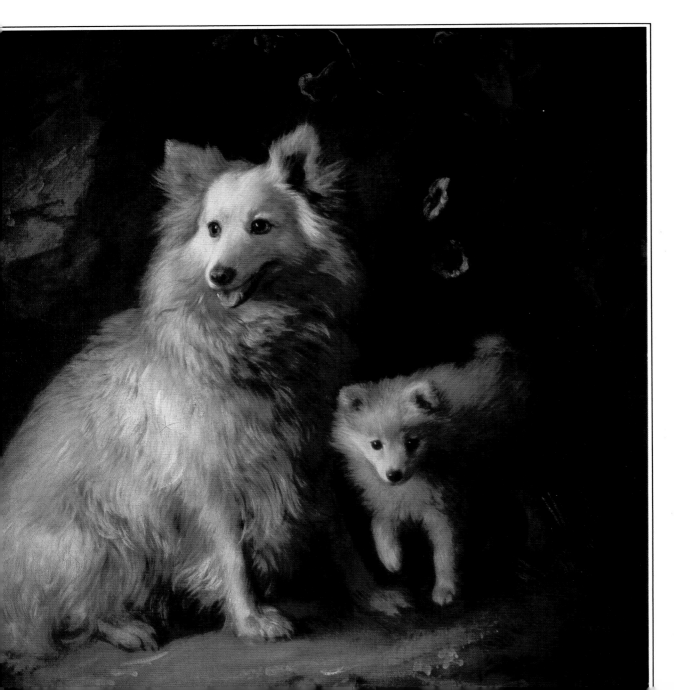

◁ **A Wooded Landscape with Horses Drinking**

Pastel

THIS ENERGETICALLY DRAWN sketch may have been an initial study for a painting or part of one, or may simply represent Gainsborough's irresistible urge to draw as he travelled around the countryside. Even his sketches, however, tended not to depict an actual, specific landscape, but rather one that he had created himself. A horse (or horses) with a downward-angled neck, often drinking, featured in many of his works and seems to have been a favourite image.

58

▷ Mrs 'Perdita' Robinson
1781

Oil on canvas

THIS DELIGHTFUL PORTRAIT, with
its lively brushstrokes and delicate
use of colour, featured at the
centre of a scandal and at the end
of a sad story. Mrs Mary
Robinson was the Prince of
Wales's mistress (she was known as
Perdita because he first met her
when she was acting in *A Winter's
Tale*) and was reputed to be
blackmailing him. A wealthy
woman, she commissioned
portraits from Sir Joshua Reynolds
and George Romney, as well as
this painting by Gainsborough, for
which, in fact, the Prince paid.
Gainsborough intended to exhibit
the work at the Royal Academy in
1782. *The Public Advertiser*
published an exposé, causing
something of a scandal.
Gainsborough withdrew the
painting, although this may have
been because Reynolds was also
exhibiting his portrait of the same
lady. Perdita fell in love with a

Detail

Colonel Tarleton. He was heavily
in debt and decided to flee the
country. She, meanwhile, managed
to raise some money and raced
after him, but during the coach
journey to Dover she was so
chilled that she became
permanently crippled at the age of
only 24. From then onwards she
was always short of money and her
possessions were auctioned in
1785 in order to pay her debts.

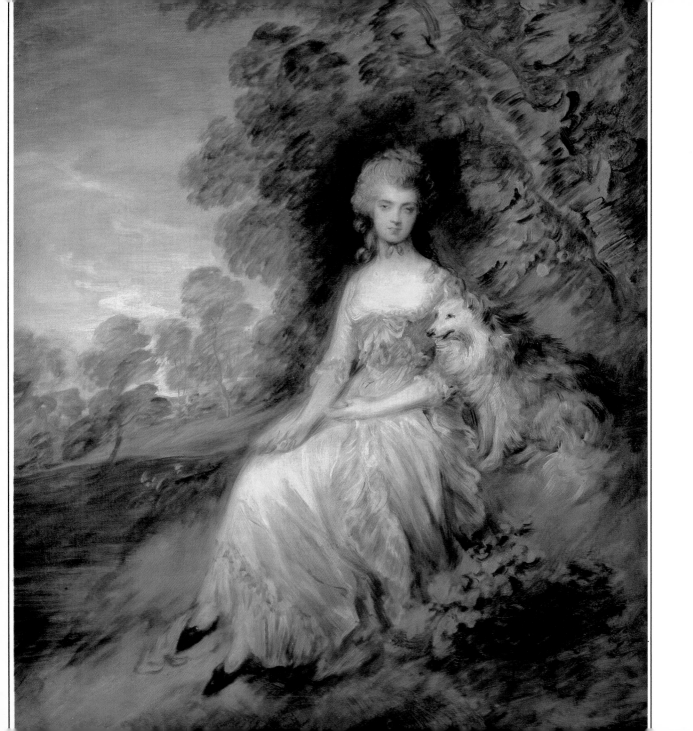

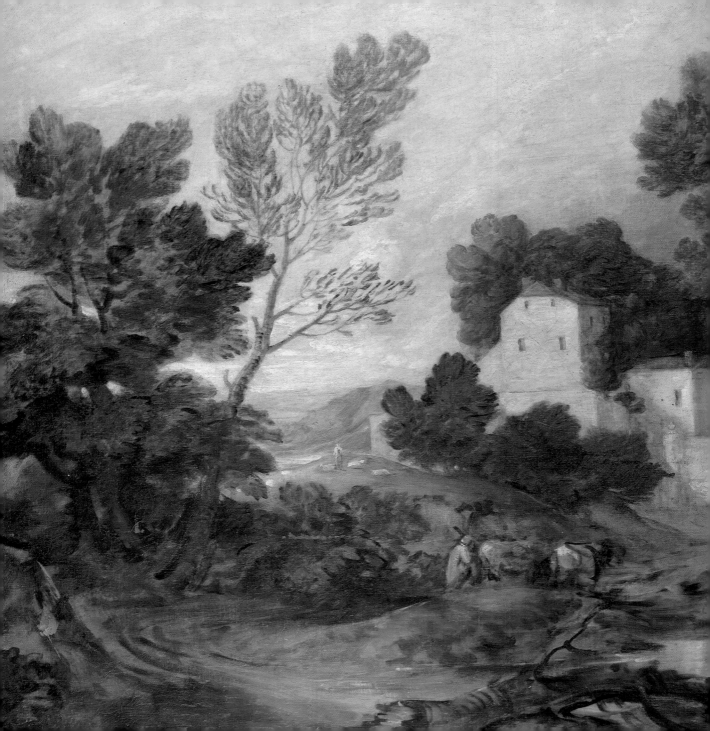

◁ **A Romantic Landscape** c. 1783-4

Oil on canvas

AN UNCOMPROMISING 'fancy picture', there is an interestingly turbulent mood to this work. Throughout his career Gainsborough made models of his landscapes, which, while based on the Suffolk countryside that he knew so intimately, were rarely true to the topographical features. He was even known to use broccoli to simulate trees! He also tended to assemble a variety of different animals, including pigs and donkeys, introducing them to his studio so that he could study his 'models'. His depiction of animals is invariably extremely precise.

▷ **Landscape: Storm Effect** 1780s

Watercolour

GAINSBOROUGH VISITED THE Lake District with his old friend Samuel Kilderbee and, hardly surprisingly, was deeply inspired by the beauty and grandeur of the landscape. Following this sketching holiday, he produced a number of stormier and more passionate landscape paintings. He seems to have intended to produce a series of oil paintings of the Lake District, but never did. In a letter shortly before the trip he wrote, 'I purpose to mount all the Lakes at the next Exhibition, in the great stile; and you know if the People don't like them, 'tis only jumping into one of the deepest of them off a wooded Island, and my reputation will be fixed for ever.'

Detail

▷ **Peasant Girl Gathering Faggots** 1780s

Oil on canvas

MODERN TASTE TENDS TO REJECT many of Gainsborough's 'fancy pictures' as full of artificial sentimentality, partly because they bear a superficial resemblance at least to some of the more mawkish productions of run-of-the-mill Victorian painters. At the time they were produced they had a freshness and inventiveness that sparked considerable interest among the public, art critics and other painters. This painting has a simplicity that would be lost by later artists painting in the same genre. Many of the models Gainsborough used for these rather narrative paintings were people he had encountered while out walking or riding around the countryside. Observing a striking face, he would persuade the owner to return home with him so that he could paint it into a 'fancy picture'.

▷ **The Morning Walk** 1785

Oil on canvas

PAINTED BY GAINSBOROUGH at the height of his powers, this is a marriage portrait of Mr and Mrs Hallett. Many art critics consider this to be his finest work. Both composition and pose are formal, as was customary with such a portrait, but the use of colour is extraordinarily subtle and presents a superb unifying element. The brushwork is delicate and precise, and the entire painting is harmonious and delightful. It is interesting to compare this painting with the marriage portrait of *Mr and Mrs Andrews* (page 11) painted at the outset of Gainsborough's career some 35 years earlier. Even then he was not content with a conventional approach. However, many years of technical experimentation and sheer hard work resulted in this elegant society portrait that gives the impression of effortless spontaneity.

Detail

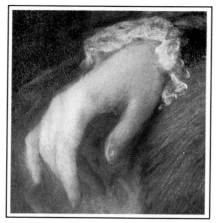

Detail

▷ **Mrs Siddons** 1785

Oil on canvas

THIS SUPERB AND POWERFUL portrait of the famous actress is one of Gainsborough's best-known and most admired works. Actresses were conventionally portrayed wearing the costume for their most famous role. Gainsborough, however, chose to paint Mrs Siddons in contemporary dress, although he did advise her to buy a new hat. He also bluntly commented, 'Madam, there is no end to your nose.' When the portrait was first exhibited it caused a sensation. Mrs Siddons' niece, Fanny Kemble, aptly commented, 'A more exquisitely graceful, refined and harmonious picture I have never seen; the delicacy and sweetness, combined with the warmth and richness, of the colouring, make it a very peculiar picture.' Certainly, Gainsborough never painted anything quite like it again.

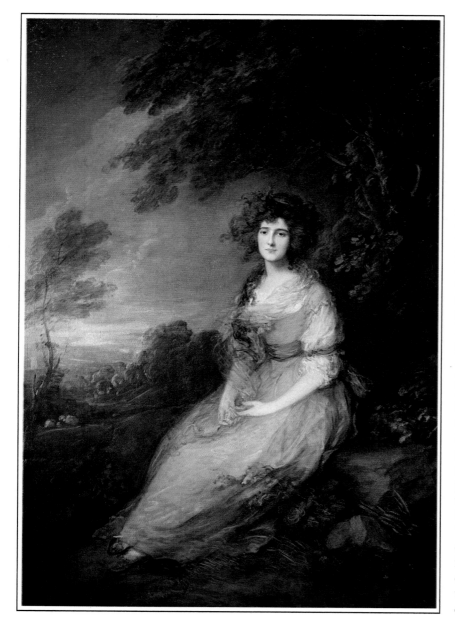

◁ **Mrs Richard Brinsley Sheridan** 1785-7

Oil on canvas

ELIZABETH LINLEY, WHOSE FATHER was Gainsborough's friend and whose portrait had been painted by him several times, was renowned for her beauty and lovely singing voice. She became engaged to a wealthy older landowner at the age of 16, but later asked him to withdraw his offer of marriage, as she had fallen in love with the playwright Richard Brinsley Sheridan. The couple eloped to France, whence she was followed by her angry father and hauled back to Bath. Eventually she and Sheridan were reunited and married under English law in 1773. This superb portrait precisely catches Elizabeth's haunting beauty and has a quality of romanticism that is unique in Gainsborough's work. Figure and landscape are unified through colour, light and overall concept. Elizabeth is dressed in peasant-like garb and is at one with nature. While Gainsborough's earlier portrait *The Linley Sisters* (page 41) depicts cultivated young women of fashion, this painting has a feeling of untamed nature and an undercurrent almost of passion, conveyed by many small details:

the wind that blows the tree's branch and Elizabeth's hair and scarf, and the plant almost intertwined with her dress, for example.

▷ **Mary, Countess Howe**
1780s

Oil on canvas

HOW GAINSBOROUGH MUST have rejoiced in this display of technical virtuosity. The transparent embroidered overskirt, the frothy lace cuffs and the heavy silk folds of the full-skirted dress all bear witness to his superb mastery of draperies. He was extremely fussy – almost obsessive – about the height at which his pictures were to be hung, as he always took great pains with the way the light struck them. He often began his portraits in a darkened room, gradually increasing the amount of light, and frequently painting by candlelight. It was through this painstaking care that he captured the sheen of silk, the rich depth of colour and his unique tactile quality.

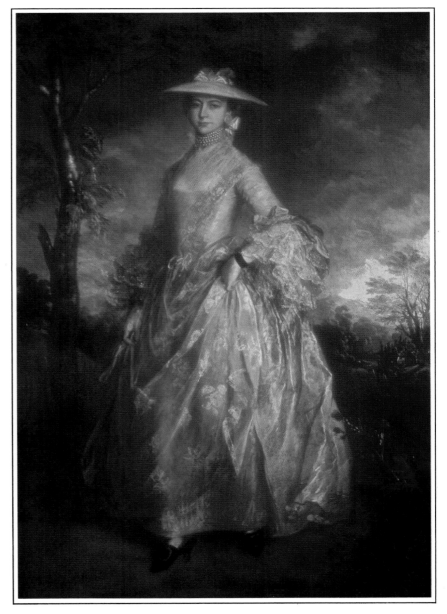

▷ **Thomas Coke** c. 1785-8

Oil on canvas

GAINSBOROUGH LOVED TO PAINT women, but was slightly less enthusiastic about portraits of men. Nevertheless, while this portrait of Thomas Coke, who later became Earl of Leicester, is in many ways a formal and conventional composition, it still has some of the hallmarks of the mature artist. The sportsman seems to be attending to his gun almost idly, with a dreamy expression on his face that is wholly in accord with the rather sombre, wintry mood of the background landscape. Perhaps he is wondering if his day's shooting will be spoiled. There is no doubt, however, about the enthusiasm of the dogs that surround his feet. Gainsborough had an unerringly accurate eye when painting animals; the dog looking up at his master is just waiting to spring out of the frame as soon as he is sent to retrieve the bird.

Detail

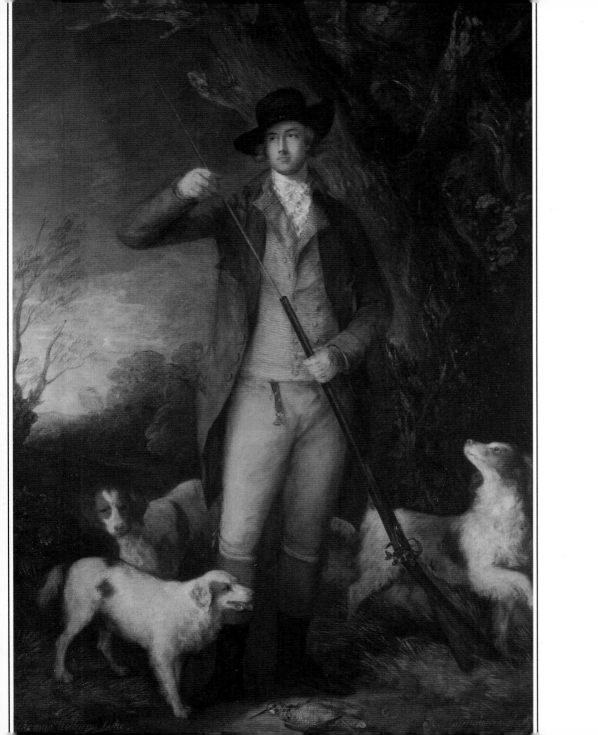

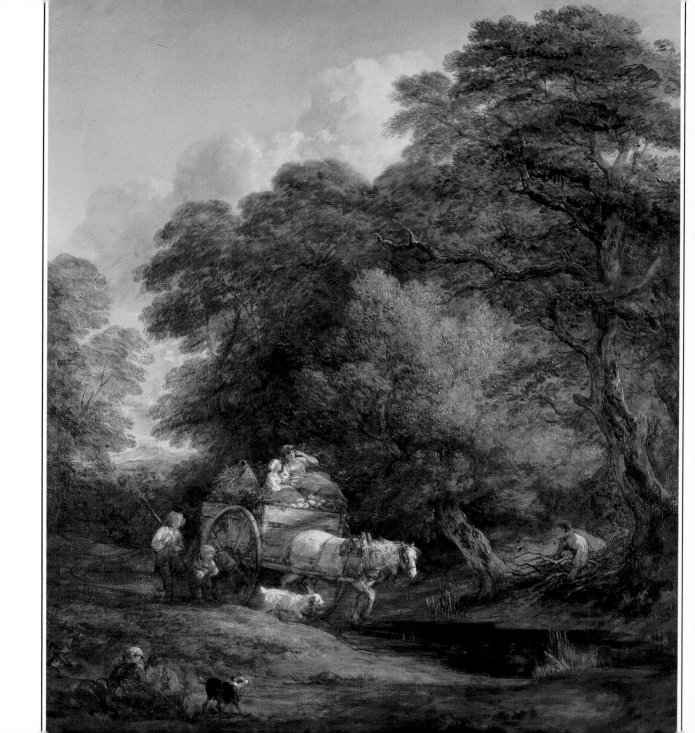

Detail

◁ **The Market Cart** 1786

Oil on canvas

THIS SHARPLY FOCUSED LANDSCAPE was first exhibited at a private view at Schomberg House, when it did not include the figure of the woodman on the right. He forms such an important part of the composition and provides such an essential highlight that it is difficult to imagine why he was not originally included. This most naturalistic of landscapes contrasts noticeably with some of Gainsborough's more romantic earlier works and represents him at his most mature.

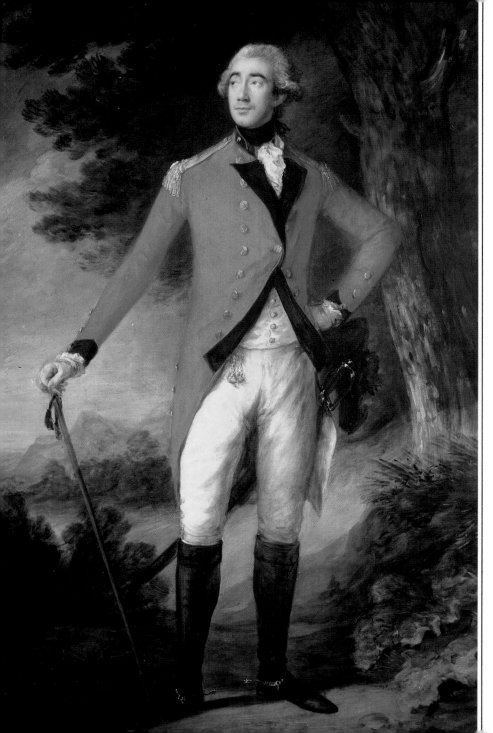

◁ **Lord Hastings, Governor of India** 1780s

Oil on canvas

There is something sadly ironic about this fine portrait of Lord Hastings depicted as an upstanding, soldierly man. On his return from India he was impeached for, among other things, bribery, corruption and misappropriation of funds. His trial was to last, on and off, for seven years. The day it began in February 1788 Gainsborough was among the interested spectators in Westminster Hall. It was then that he experienced the first, ominous symptoms of the cancer of which he would die later in the year.

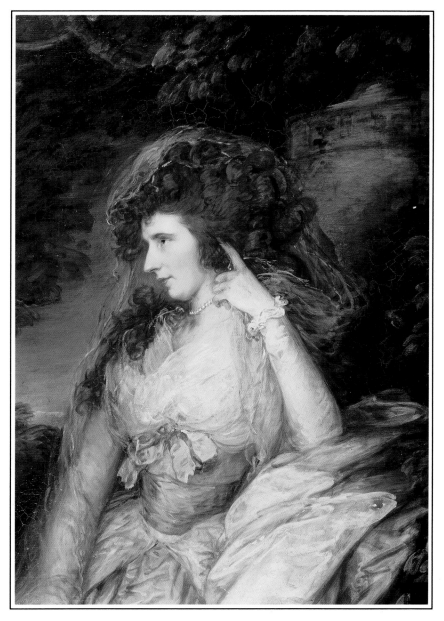

▷ **Mary, Lady Bate-Dudley**
1787

Oil on canvas

THE REVEREND SIR HENRY Bate-Dudley, the influential editor of the *Morning Herald*, was a powerful and loyal friend to Gainsborough, whom he admired and liked as both painter and man. He had been particularly supportive after the break with the Royal Academy in 1784, lavishly praising the paintings Gainsborough exhibited privately at Schomberg House. This portrait of Lady Bate-Dudley shows the dynamism and élan typical of Gainsborough's portraits of friends, with lively brushstrokes and a freer use of paint than in his more formal commissions.

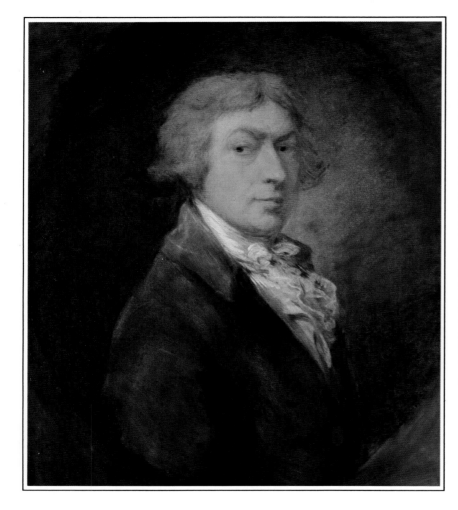

◁ **Self Portrait** 1787

Oil on canvas

SIX SINGLE SELF-PORTRAITS
survive and this one, painted when
Gainsborough was 60 years old, is
the last. It may have been painted
for his friend the musician Karl
Friedrich Abel, whom he had
known since moving to Bath
nearly 30 years previously. To
Gainsborough's great grief his
friend died in 1787, probably
before the painting was completed.
It has a slightly 'sketchy' feeling
about it, but then all
Gainsborough's more intimate
portraits were painted with a freer
hand. He depicts himself as a fit
and upright man in the prime of
life, showing no sign of the
terminal illness that was soon to
overtake him.